Volume III

SON
⊞ OF ⊞
MAN

KING OF KINGS

Volume III

SON

OF

MAN

KING OF KINGS

by Susan Easton Black

Artwork by Liz Lemon Swindle

The Greenwich Workshop Press

Seymour, Connecticut

A GREENWICH WORKSHOP PRESS BOOK

Copyright ©2007 by The Greenwich Workshop Press
All art ©Liz Lemon Swindle

Published by the Greenwich Workshop, Inc., 151 Main St., P.O. Box 231, Seymour, CT 06483. (203) 925-0131 or (800) 243-4246.

Library of Congress Cataloging-in-Publication Data

Black, Susan Easton
 Son of Man : king of kings Vol. III / by Susan Easton Black ; artwork by Liz Lemon Swindle.
 p. cm.
 Includes bibliographical references.
 ISBN 978-0-86713-094-2 (alk. paper)
 1. Jesus Christ—Biography. 2. Jesus Christ—Mormon interpretations. I. Title.

BT310 .B53 2001

232.92—dc21

 2001040314

FOR FURTHER READING

The Holy Bible containing the Old and New Testaments. Authorized King James Version. Translated out of the original tongues and with the former translations diligently compared and revised by His Majesty's special command.

J.R. Dummelow, ed., *A Commentary on the Holy Bible* (New York: Macmillan Company, 1964).

Alfred Edersheim, *Jesus the Messiah: An Abridged Edition of the Life and Times of Jesus the Messiah* (Grand Rapids, Michigan: Wm. B. Eerdmans Publishing Company, 1976).

Ralph Gower, *The New Manners and Customs of Bible Times* (Chicago, Illinois: Moody Press, 1987).

National Geographic Society, *Everyday Life in Bible Times* (National Geographic Society, 1967).

Wolfgang E. Pax, *Footsteps of Jesus* (Jerusalem, Israel: Nateev Publishing, 1970).

Hayyim Schauss, *The Jewish Festivals: A Guide to Their History and Observance* (New York: Schocken Books, 1938).

James E. Talmage, *Jesus the Christ* (Salt Lake City, Utah: Deseret Book Co., 1983).

Jacket front: *Prince of Peace*
Book design by Scott Eggers, Salt Lake City
Manufactured in China by Oceanic Graphic Printing
First Printing 2007

2 3 4 5 10 09 08 07

CONTENTS

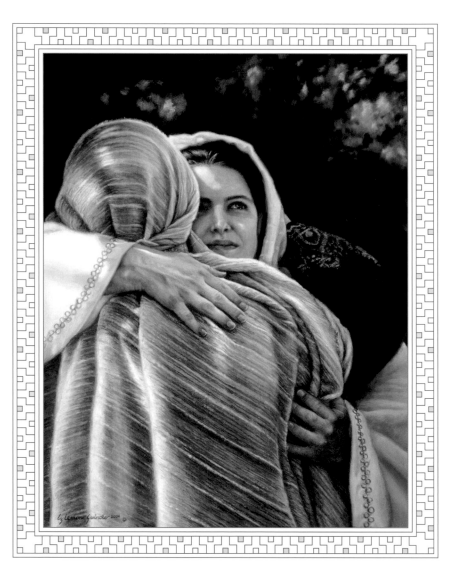

REFUGE

HOW DO two women, who live rather ordinary lives, depict heart-wrenching scenes—scenes that tried the souls of the disciples of Jesus and Mary, his mother, as she stood by the cross? It would have been easy for them to have ended the Son of Man series with the greeting of Gabriel to Mary, "Hail, thou art highly favoured, the Lord is with thee: blessed art thou among women," or when Elisabeth welcomed Mary with these words, "Blessed art thou among women, and blessed is the fruit of thy womb." But author and artist know the real story of Jesus centers on the last week of his mortal ministry. This week was the climax of his mortality—for this he was born and for this he died. ¶ Knowing the trials associated with the last week, Jesus did not turn from his appointed destiny. He moved confidently forward, knowing that he was fulfilling the will of his father. For his greatness that final week, generations have proclaimed and will proclaim him King of Kings. Yet could the talents of artist and author ever be good enough to portray this story of sacrifice, atonement, death, and resurrection? ¶ Leaning heavily on their conviction that Jesus is the Christ, they now respectfully share their work. For Susan, writing this manuscript has given greater meaning to her life. She found, through the process, that insurmountable challenges were overcome due to her knowledge that Jesus is the Christ. For Liz, the glorious resurrection of our Lord and Savior holds unspeakable joy because it means that one day she will be with her parents again and can tell her father, "Thanks for bringing home tomato soup labels from the cannery. I used the back of the labels as a 'sketch pad.' I painted the King of Kings."

— Susan Easton Black

HOSANNA
TO THE SON
OF DAVID

NEAR THE small village of Bethphage on the eastern slope of the Mount of Olives, Jesus stood conversing with his disciples. There he instructed two of the disciples to go into the village and "ye shall find a colt tied, whereon never man sat." They were told to loose the animal and bring it to the Master. "If any man say unto you, Why do ye this? say ye that the Lord hath need of him; and straightway he will send him hither." The disciples went into the village, unloosed the colt, and brought it to Jesus. They then spread their outer garments on the

donkey's back, an ancient sign that their Master was the King of Kings, the Lord of Lords. Accepting their gesture, Jesus mounted the donkey and descended from the Mount of Olives through the Kidron Valley to the Holy City below. In so doing, he fulfilled the prophesy "Thy King cometh [into Jerusalem] unto thee, meek, and sitting upon an ass."

A multitude gathered near the gates saw him approaching the city. Recognizing the ancient sign of royalty—a man riding a garment-laden ass—they spread their garments in his way, broke palm branches from the trees and waved them aloft as they shouted: "Hosanna to the Son of David: Blessed is he that cometh in the name of the Lord; Hosanna in the highest." To his disciples and the crowd that day, Jesus of Nazareth was the Hope of Israel, the Triumphant Conqueror, the King of Kings.

But the praise and adulation ended all too soon. The multitude dispersed and every man went his way. Did they not recognize that the Messiah had entered the Holy City? Had they merely feigned recognition? Had those who dropped branches and allowed their shouts of adulation to fade become like the five foolish virgins who went "forth to meet the bridegroom" but were unprepared? Certainly the multitude had heard the cry, "Behold, the bridegroom cometh; go ye out to meet

TRIUMPHAL ENTRY

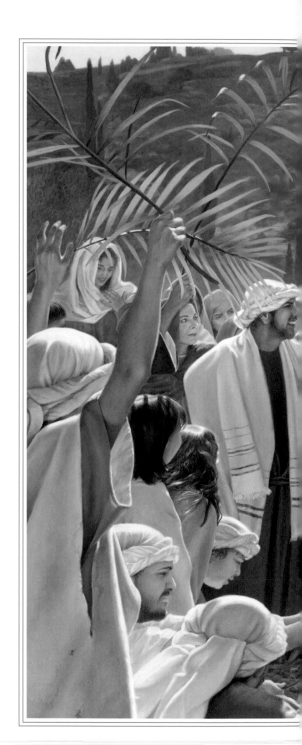

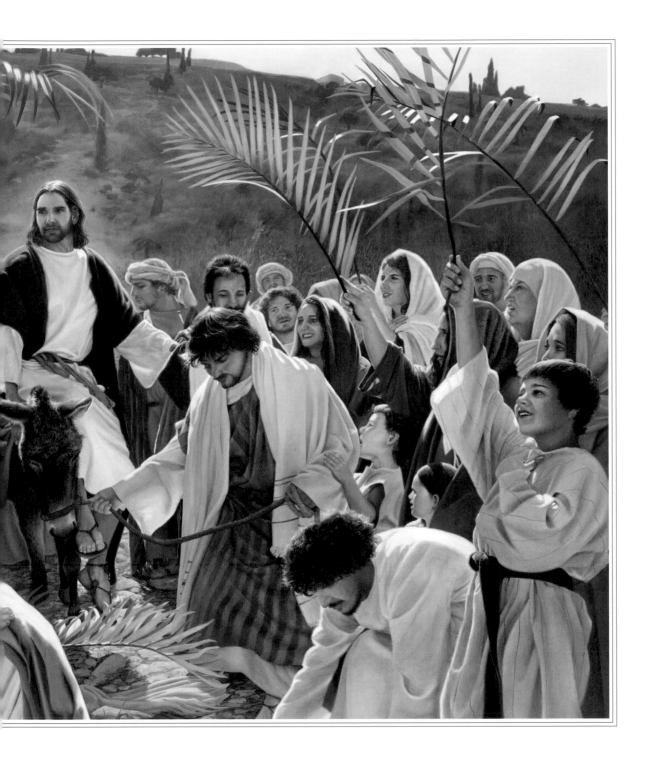

him," yet their adoration was fleeting for they lacked the faith to truly see him. They believed the man on the ass was the miracle worker of Galilee, and nothing more. Like the foolish virgins, who thought that they could scurry to market to buy oil in time for the marriage feast, the multitude missed the significance of the event. The bridegroom had entered the Holy City. The admonition to "watch therefore, for ye know neither the day nor the hour wherein the Son of man cometh" had failed to capture the attention of the unprepared.

Could the multitude be faulted? Jesus thought so. In his parable of the fig tree, he spoke of branches being tender and putting forth budding leaves. As summer grew nigh, he noted a dramatic change in the branches. They had grown strong and heavy with life-bearing fruit. Was the multitude like the fig tree of the parable—either tender in the faith or strong in the conviction of his identity? Had they heeded the admonition, "when ye shall see all these things," know that the coming of the Son of Man is near? No! They were like the deceptive fig tree Jesus had seen that had a leafy facade with the appearance of having born fruit, but no life was found beneath its broad leaves. That fig tree withered and died much like the fate awaiting the rebellious and unbelieving of the House of Israel.

I KNOW THEE NOT *(Parable of the ten virgins)*

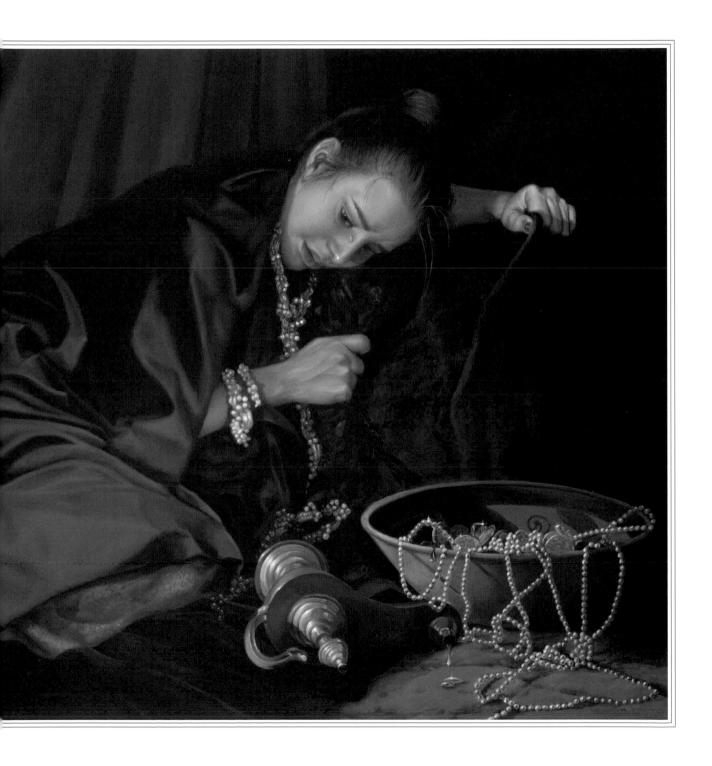

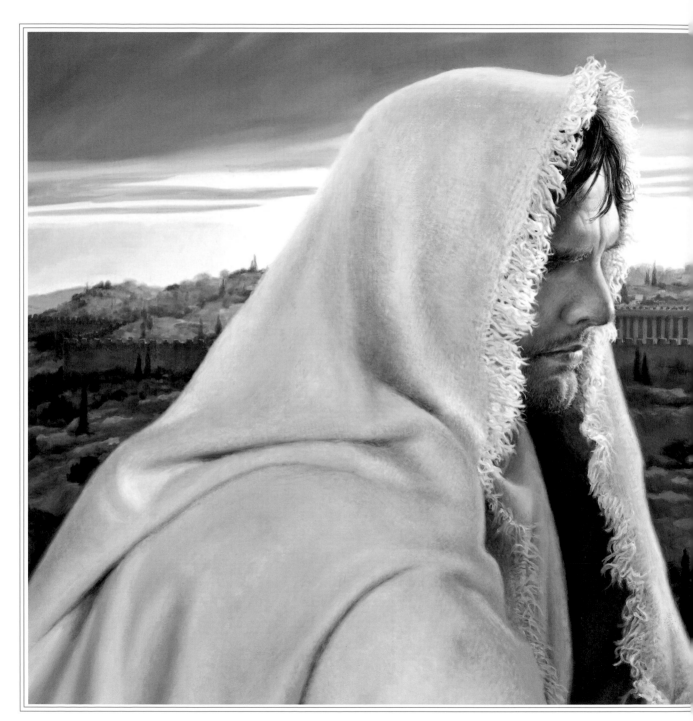

NO MAN KNOWETH *(Parable of the fig tree)*

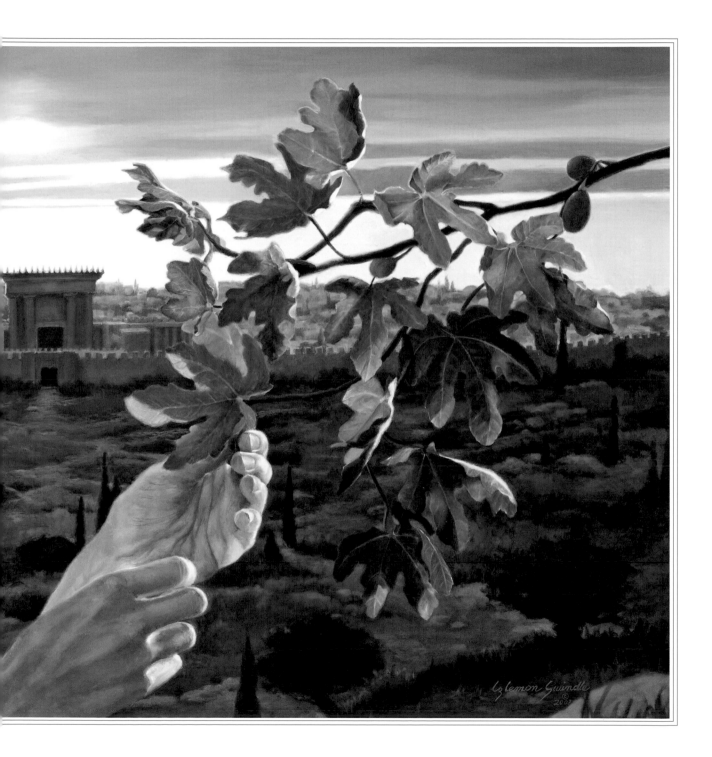

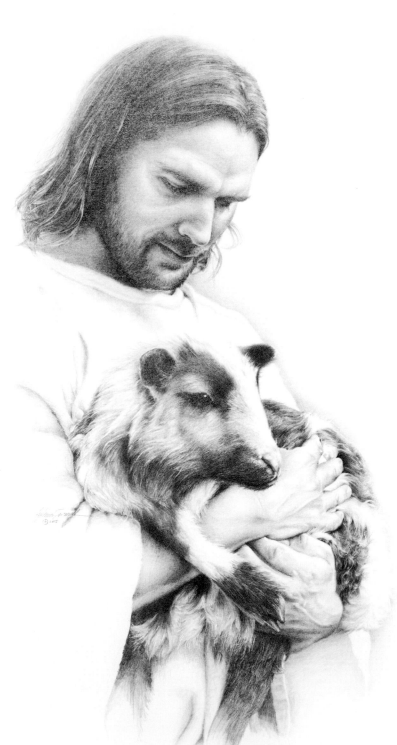

None, save Jesus of
Nazareth, knew that
the time of the ultimate
sacrifice of the Son of
God drew near.

Faith was a rare commodity in Jerusalem that Passover week. Too many years of foreign rule had taken its toll on the beleaguered people. Yet if there were a spark of faith, Passover would surely be the catalyst. During this holy week, Israelites paused to remember the goodness of Jehovah who had redeemed their ancestors from Egyptian rule. None could avoid the complex scene of thousands of lambs slaughtered on the Temple Mount as a symbolic reminder of the ultimate future sacrifice of the Son of God. Yet the climax of that holy week was missing—the sacrifice of the Son.

How long could the House of Israel wait before they greeted the King of Kings, their sacrificial lamb? How many Passover feasts must be eaten before Jehovah would save the Israelites from Roman bondage? For many, the answers to these questions appeared endless. None, save Jesus of Nazareth, knew that the time of the ultimate sacrifice of the Son of God drew near. None, save Jesus, knew that this would be the final Passover week. For that last feast, a celebration of the old and a beginning of the new testament, Jesus wanted everything to be made ready.

"Go ye into the city," Peter and John were instructed. "There shall meet you a man bearing a pitcher of water: follow him." Then say to the man, "The Master saith unto thee, Where is the guestcham-ber, where I shall eat the passover with my disciples? And he shall shew you a large upper room furnished: there make ready." Peter and John found the man with a pitcher of water just as Jesus had said. They followed him to his home, where they were shown a large, upper chamber on the roof. To Peter and John, the chamber was a choice setting in which to hold the Passover feast. Along with the good man of the house, the two disciples prepared the room. Rugs, pillows, divans, and tables were made ready as a sacrificial lamb slowly roasted on a pomegranate spit. Lamps were lit, tables were set, unleavened cakes baked, and bitter herbs gathered, all in preparation for the feast. When everything was made ready, Peter and John left the good man's house to find Jesus and the other disciples and bring them to the upper room.

Once assembled in the room, there was little time to talk of the merciful deliverance of their forebears from oppressive Egyptian servitude. As Jesus "sat down with the twelve," some, like the Pharisees and Sadducees clamoring for the chief seats in the synagogues, began to quarrel over who would sit next to him. It was customary for the host, in this case Jesus, to invite his closest friends to sit on either side of him. Jesus chose Judas to sit on his left side, the place of honor, and John the Beloved to sit on his right. When

the other apostles were seated, Jesus said, "With desire I have desired to eat this passover with you before I suffer: For I say unto you, I will not any more eat thereof, until it be fulfilled in the kingdom of God." Was the suffering he referred to the long anticipated suffering of the Son of God? On this night would the Lamb of God save his people? On this night would God save the world?

Before the queries subsided, the formal Passover service began. Since formalities varied, the procedures followed in the upper room are uncertain. None question, however, that Jesus arose, "laid aside his garments," and "took a towel, and girded himself" before pouring water into a basin for the purpose of washing the feet of his disciples—an act reserved for a common slave.

Jesus arose and poured water into a basin for the purpose of washing the feet of his disciples—an act reserved for a common slave.

"Thou shalt never wash my feet!" exclaimed Peter. "If I wash thee not," Jesus replied, "thou hast no part with me." Wanting to be with him always, Peter said, "Lord, not my feet only, but also my hands and my head."

Jesus then pronounced the men "clean every whit," but not all. Who was he referring to? Surely not the man seated at his left in the place of honor. "I say unto you, that one of you shall betray me," said Jesus, "woe unto that man by whom the Son of Man is betrayed! it had been good for that man if he had not been born." The concerned phrase "Lord, is it I?" filled the air. Jesus answered, "He it is, to whom I shall give a sop, when I have dipped it." Judas asked, "Is it I?" Jesus replied, "Thou hast said." He then dipped the sop and gave it to him, advising, "That thou doest, do quickly." Judas withdrew from the upper room to betray the Son of God.

With him gone, those in the room were now clean. As such, they were prepared to receive a new law, a new testament, a covenant that Judas would never know. Jesus took the round, unleavened bread, "blessed it, and brake it, and gave it to the disciples, and said, Take, eat; this is my body. This do in remembrance of me." Jesus then "took the cup, and gave thanks, and gave it to them, saying, Drink ye all of it; For this is my blood of the new testament, which is shed for many for the remission of sins." His words were of an atonement, not of Passover. He made no mention of parting the Red Sea, freeing the Israelites from

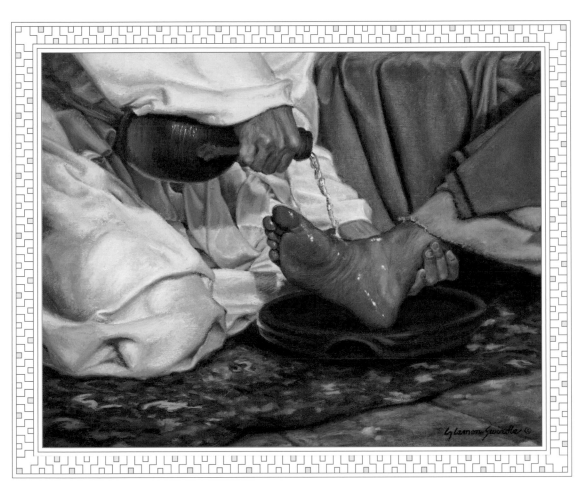

WASHING OF FEET

Egyptian bondage, or leading his people to the promised land. This Passover was indeed a departure from tradition—it was new.

When Jesus spoke of remembrance, blood, and remission of sins he referred to the atonement—the final sacrifice. Although these words were welcomed by the sinner, that night in the upper room they evoked a sense of fear and foreboding, a certain finality. Did the words mean that sorrow and death were close at hand? Would Jesus leave them? Wanting to comfort his followers, Jesus promised, "Peace I leave with you, my peace I give unto you: not as the world giveth, give I unto you. Let not your heart be troubled, neither let it be afraid." Live a new commandment, "That ye love one another; as I have loved you, that ye also love one another. By this shall all men know that ye are my disciples, if ye have love one to another."

Jesus then prayed to the Father. In that sacred utterance, he offered himself as a ransom for the sins of the world and acknowledged that his earthly ministry had ended. Knowing his apostles would take his gospel message to the world, he pleaded for mercy on behalf of them and those who would believe their words. When his prayer ended, so did the many reasons for Jesus and his apostles to be in the upper room. The hour had come for the Son of Man to become the Sacrificial Lamb. The hour had come for the world to be redeemed. A lonely garden awaited. He must not tarry.

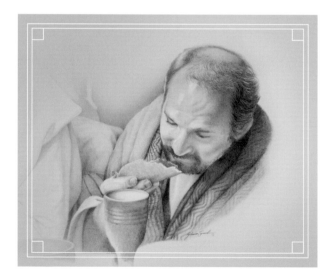

LAST SUPPER *(Detail)*

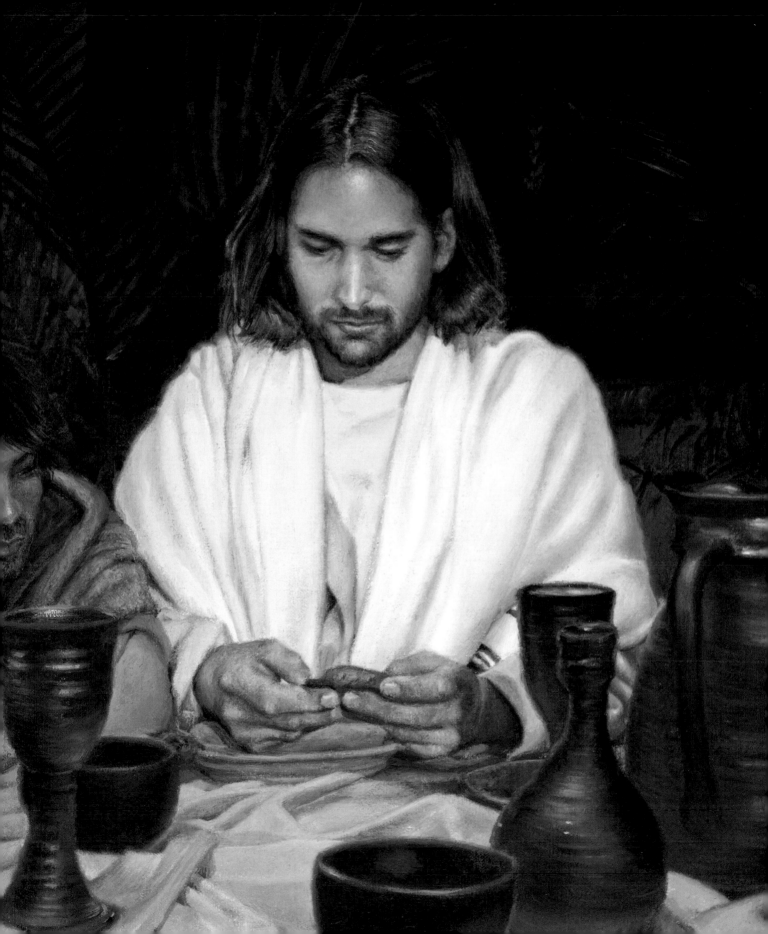

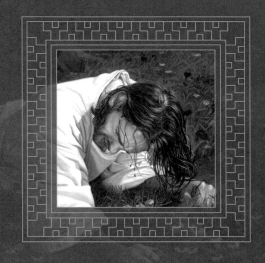

HAIL!
KING OF
THE JEWS

CHAPTER 2

JESUS AND HIS disciples left the upper room, walked through the old city, and crossed the Kidron Valley to reach the hillside of the Mount of Olives. There, among the gnarled olive trees that had graced the Garden of Gethsemane for centuries, they stopped. "Sit ye here, while I go and pray yonder," Jesus instructed his disciples. Only Peter, James, and John were invited to follow him into a more secluded area of the garden. As they walked, Jesus spoke of the sorrow that had begun to overtake him. The infinite atonement—the sacrifice

of the Lamb of God—had begun. Much like the heavy stone of the Gethsemane, which crushed olives to produce the desired oil, the weighty burden of sin and sorrow now pressed upon Jesus.

Turning to his disciples, Jesus said, "My soul is exceeding sorrowful, even unto death: tarry ye here, and watch with me." Alone, he went a stone's cast away before falling to his face and exclaiming, "O my Father, if it be possible, let this cup pass from me: nevertheless not as I will, but as thou wilt. Father, save me from this hour: but for this cause came I unto this hour." For this cause, his blood was spilt in anguish and he "suffered the pain of all men, that all men might repent and come unto him." Yet Peter, James, and John were unaware—although instructed to watch, they had allowed sleep to overtake them.

When Jesus returned and found them in a deep slumber, he asked, "Simon [Peter], sleepest thou? couldest not thou watch one hour?" Without waiting for a reply, Jesus removed himself once again to pray to His Father. "O my Father," said Jesus, "if this cup may not pass away from me, except I drink it, thy will be done." The Father's will was done that night in Gethsemane. There, amid the shadows of ancient trees and the comfort of an angel, Jesus of Nazareth became the Savior, the Deliverer, the Redeemer of us all. There, he triumphed

GETHSEMANE

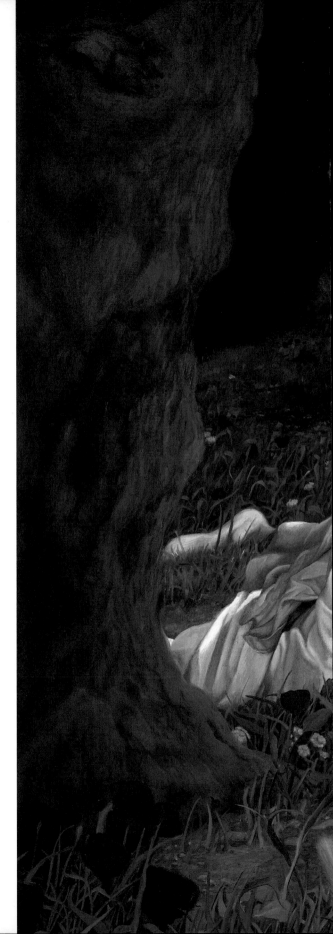

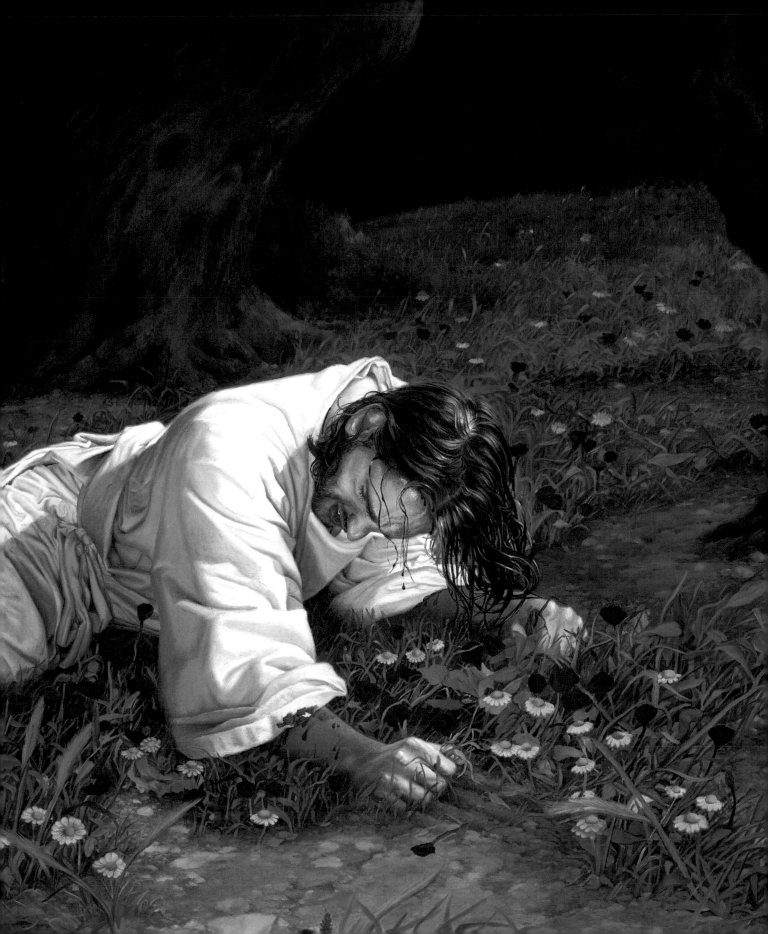

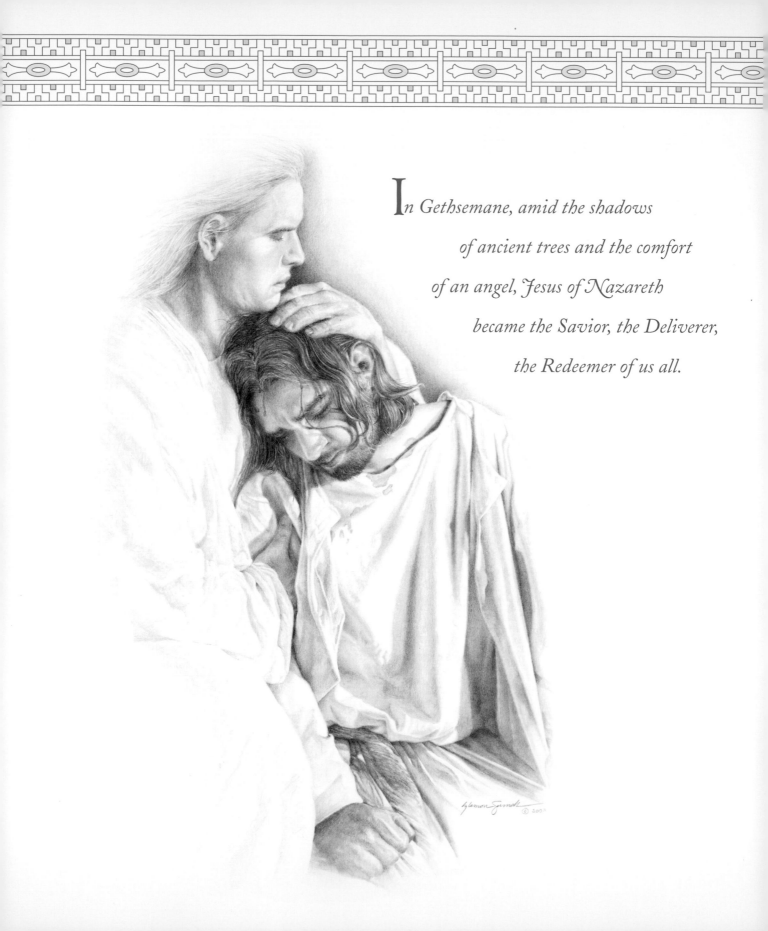

In Gethsemane, amid the shadows
of ancient trees and the comfort
of an angel, Jesus of Nazareth
became the Savior, the Deliverer,
the Redeemer of us all.

over sorrow and sin, giving the world an infinite atonement, his greatest miracle.

Instead of receiving gratitude, adoration, and honor at his triumph over adversity, Jesus was subjected to yet another soul-wrenching drama, this one at the instigation of a once-favored disciple, Judas. Judas, who had abruptly left the Passover festivities in the upper room, was leading a multitude of boisterous men armed with staves and swords up the Mount of Olives hillside to the garden where Jesus and his disciples stood. For thirty pieces of silver, Judas had betrayed their Master. Soldiers, who followed close at his heels, had been instructed, "whomsoever [he] shall kiss, that same is [Jesus]: hold him fast."

Judas found Jesus and the other disciples in the Garden of Gethsemane, a garden made holy by sacrifice. Feigning his own devotion, Judas stepped forward and kissed Jesus. The soldiers recognized the sign and seized Jesus, taking him prisoner. Peter, angered by their actions, drew a sword and struck Malchus, "a servant of the high priest's, and smote off his ear." Turning to Peter, Jesus firmly stated, "Put up again thy sword into his place: for all they that take the sword shall perish with the sword." By the mere touch of the Master's hand, Malchus was made whole.

"Thinkest thou that I cannot now pray to my Father, and he shall presently give me more than twelve legions of angels?" Jesus asked Peter and the

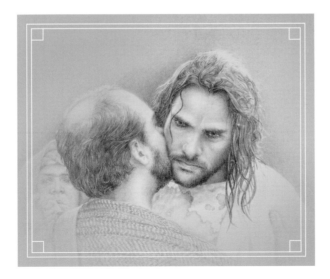

soldiers. None dared reply. The request for heavenly legions was not uttered for this was the prophesied night when the workers of evil would have their way with the Son of God. Jesus would not interfere with their moment of hollow triumph. He allowed the captain and officers to deliver him to their superiors.

Throughout the evening and early morning hours that followed, Jesus was the defendant in a series of trials that involved the highest government leaders. The first trial was before Annas, the most influential Jew of his day. In his palace, Jesus was subjected to ridicule and mockery. In the palace of Joseph Caiaphas, the Roman-appointed high priest and son-in-law of Annas, ridicule and mockery escalated. During the so-called judicial proceeding in that palace, Jesus was smitten and blindfolded. The abusive actions were reprehensible in any court in the land, yet none in the palace objected. "Art thou the Christ, the Son of the Blessed?" Caiaphas asked Jesus. Without hesitation, Jesus replied, "I am: and ye shall see the Son of Man sitting on the right hand of power, and coming in the clouds of heaven."

His choice of words "blessed" and "power" greatly upset Caiaphas, for "blessed" and "power" were words reserved for defining God. Was Jesus claiming "for human or demon power the prerogatives of God, or in dishonoring God by ascribing to Him[self] attributes short of perfection?" To the assembled judges, the answer was clear. By his own admission, Jesus had committed blasphemy. "What need we any further witnesses?" asked Caiaphas. "Ye have heard the blasphemy: what think ye?" With resolute voices, the assembled cried, "He is guilty of death." They stepped forward and spit on the face of Jesus, buffeted and hit him "with the palms of their hands," as they shouted the taunting refrain, "Prophesy unto us, thou Christ, Who is he that smote thee?"

The next trial commenced early in the morning before the Great Sanhedrin, the highest governing body of the Jews. The Sanhedrin also found Jesus guilty of blasphemy, a serious crime in Judaism. The verdict was sure, but the execution of judgment—death—was questioned. According to rabbinic law, a blasphemer was to die by stoning and have his body suspended from a tree. The problem for the Sanhedrin was that execution for blasphemy was illegal in Judaea under Roman law. Since Rome ruled the land, the question of how to execute judgment under legal restraints of foreign rule was paramount.

The Sanhedrin met and "took counsel against Jesus to put him to death" and concluded that the way to carry out this sentence was to deliver Jesus to Pontius Pilate, the Roman-appointed governor of Judaea, who

Before Annas, the most influential Jew of his day,
Jesus was subjected to ridicule and mockery. In the palace of
Joseph Caiaphas, the Roman-appointed high priest
and son-in-law of Annas, ridicule and mockery escalated.

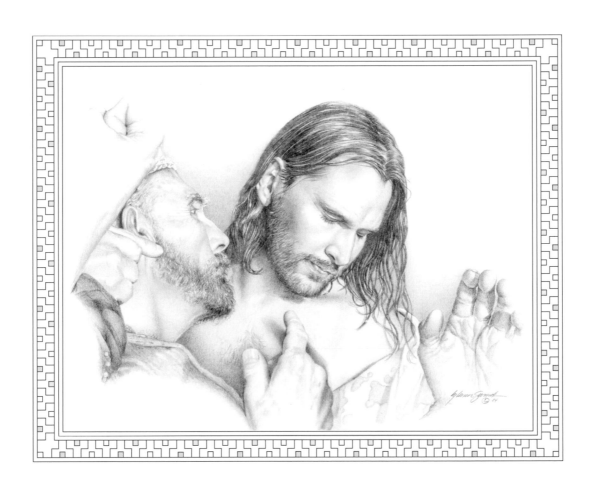

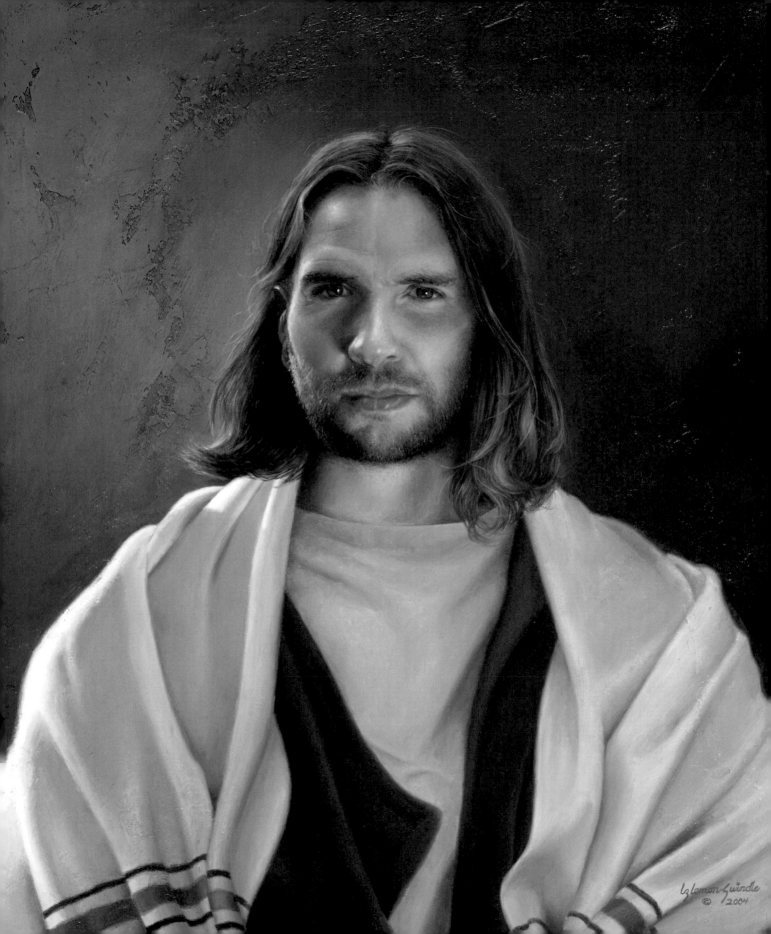

had the power to inflict the death penalty. Would Pilate be a cooperating puppet to their scheme? Could he be persuaded that Jesus of Nazareth was a revolutionary, guilty of treason against Rome? The stakes were high and the conclusion uncertain as the Sanhedrin delivered Jesus to Pilate's soldiers stationed at the Antonia Fortress in Jerusalem.

Jesus entered the fortress at the soldiers' insistence, but his accusers, members of the Great Sanhedrin, did not follow behind. Entrance for them into a gentile structure was prohibited due to their belief that a Jew defiled himself by stepping inside a foreign-owned building. Although interested in Pilate's judgment of Jesus, they preferred to remain outside the fortress, near the gate. There, they shouted accusations of sedition and treason against Jesus, hopeful that this would persuade Pilate that the prisoner was guilty of these crimes and therefore must be put to death.

Jesus stood before the governor Pontius Pilate in the Hall of Judgment. "Art thou the King of the Jews?" asked Pilate of Jesus. He replied, "Thou sayest it." "Hearest thou not how many things they witness against thee?" Pilate asked Jesus, speaking of the words shouted by the Jewish leaders standing near the gate of the fortress. Jesus "answered him to never a word; insomuch that the governor marvelled greatly." Pilate

left Jesus standing in the Hall of Judgment to go outside, where he met with the Jewish leaders, still shouting charges against the prisoner. "What accusation bring ye against this man?" he asked. They replied, "If he were not a malefactor, we would not have delivered him up unto thee." Pilate advised, "Take ye him, and judge him according to your law." The leaders failed to reveal to the Roman governor that they had already judged him and found him guilty of blasphemy. Instead, they said, "It is not lawful for us to put any man to death."

Returning to the Hall of Judgment, Pilate asked Jesus, "Art thou King of the Jews?" Jesus answered with a question of his own: "Sayest thou this thing of thyself, or did others tell it thee of me?" Pilate asked, "Am I a Jew? Thine own nation and the chief priests have delivered thee unto me: what hast thou done?" Jesus said, "My kingdom is not of this world: if my kingdom were of this world, then would my servants fight, that I should not be delivered to the Jews."

Pilate again left the Hall of Judgment to speak with the Jewish leaders outside the fortress. "I find in [Jesus] no fault at all," he said to them. He then revealed that his inclination was to free the man whose kingdom was not of this earth. Pilate's words of expectant mercy angered the clamorous leaders, who had

With Pilate watching them,
they stripped Jesus of his garments
and strapped him to a pillar.
Then they scourged him
with a leather whip
weighted with sharp
pieces of stone, lead balls,
and sheep bone.

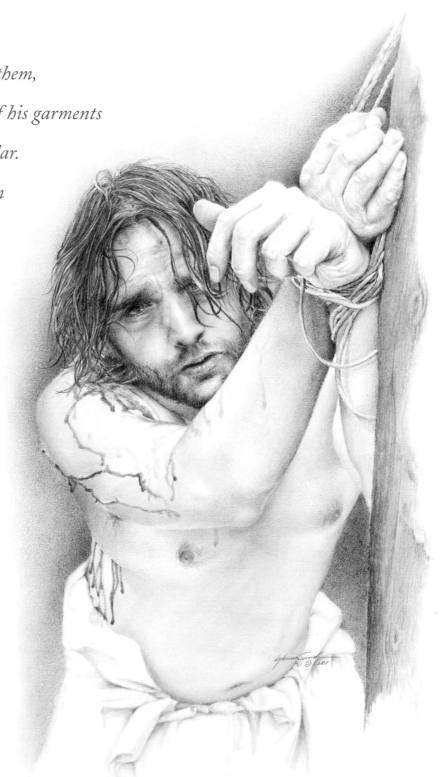

shouted for a judgment of death against an insurrectionist. Would Pilate not bow to their wishes? Wanting to sway the balance of judgment to conviction and death, they shouted more accusations against Jesus until Pilate could ignore them no longer.

Frustrated with the Jewish leadership and looking to escape the mounting tension near his fortress, Pilate passed the judgment of Jesus to Herod Antipas, the Roman-appointed tetrarch of Galilee, who was in Jerusalem for the Passover festivities. After all, Jesus was a Galilean. Who better to judge him than the tetrarch of Galilee? Herod was "exceeding glad" that Pilate sent Jesus to him. He had wanted to talk with this Galilean ever since the death of John the Baptist. Herod had heard much about the miracles performed by Jesus near the Sea of Galilee and wanted a miracle performed just for him.

To Herod's disappointment, the prisoner refused to speak, let alone perform a miracle. His silence did not ruin the occasion for Herod, however. He and his men turned the quiet into merriment. They "set [Jesus] at nought, and mocked him, and arrayed him in a gorgeous robe," like the robes worn by Jewish nobility and festive Passover pilgrims. Little did Herod or his guards know that their actions and the silence of Jesus had been foretold by the ancient prophet Isaiah: "He was oppressed, and he was afflicted, yet he opened not his mouth."

Having nothing but silence with which to judge the prisoner, Herod believed himself unable to execute judgment against Jesus and sent him back to Pilate. Pilate, not wanting to render a judgment against the prisoner, "for he knew that for envy [the Jewish leaders] had delivered him," offered the leaders, still lingering outside the fortress, an opportunity to choose the release of one prisoner, a traditional Roman custom during Passover festivities. "Whom will ye that I release unto you? Barabbas, or Jesus which is called Christ?" Unexpectedly, Barabbas—a man convicted of inciting an insurrection and committing murder—was their choice.

"What shall I do then with Jesus which is called Christ?" asked Pilate of them. "Let him be crucified," was their cry. Crucifixion was the most cruel and hideous of punishments inflicted upon a prisoner in the Roman Empire. It was reserved for rebels against Rome, delinquent slaves, robbers, and deserters. Pilate questioned aloud the crowd's cry of crucifixion for Jesus. "Why, what evil hath he done?" he asked those outside of the gate. Without answering his question, the agitated Jewish leaders yelled, "Let him be crucified." Unable to sway them, but wanting to assure both

Jew and gentile that he believed Jesus of Nazareth innocent of sedition and revolutionary actions, Pilate gave two symbols to verify the fact that he found the condemned innocent. His gentile symbol was to arise from the judgment seat before issuing a decree, which symbolized innocence. The Jewish symbol came when he called for a bowl of water and washed "his hands before the multitude." The washing of hands signified to the Jews that he disclaimed responsibility for the sentence of death. "I am innocent of the blood of this just person: see ye to it," Pilate said. The incited throng shouted, "His blood be on us, and on our children."

Barabbas, the insurrectionist and murderer, was released from prison into the welcoming arms of the multitude. Jesus, the condemned, was forcefully taken from the Hall of Judgment to the Common Hall in the fortress, where "the whole band of soldiers" had gathered in anticipation of his arrival. It was customary for them to mock the condemned before executing Pilate's mandate of judgment. With Pilate watching them, they stripped Jesus of his garments and strapped him to a pillar or frame from which he was helpless to retreat. Then they scourged him with a leather whip weighted with sharp pieces of stone, lead balls, and sheep bone. Shortly thereafter they dressed him in a makeshift kingly fashion. A short scarlet or purple sagum, a woolen war cloak often worn by Roman generals, was fastened by a clasp over his shoulder. A twisted garland of thorns was placed upon his head to symbolize a crown, and a reed put in his right hand to imitate a scepter. To the soldiers in the Common Hall that day, Jesus was adorned as a king, even the King of the Jews. On bended knee, they approached him, exclaiming, "Hail, King of the Jews!" They then spat on him and struck him with the reed.

There is little excuse for the blatant disdain of the King of Kings. Nothing in the ruling of Pilate demanded such abhorrent mockery. Did the soldiers not know that the makeshift attire—from the scarlet sagum to the twisted garland—bespoke the true identity of the condemned? Did they not know that Jesus was the King of Kings? If they had known, none would have spit or struck, for he was their true Master.

After this ordeal, Pilate presented Jesus to the boisterous crowd standing near the fortress. "Behold your King!" he announced. Pilate's choice of words, his acknowledgment of Jesus as king, was unacceptable to the crowd. Jesus of Nazareth, the healer of Galilee, was not their king. "Away with him, away with him, crucify him," was their retort. "Shall I crucify your King?" Pilate inquired? The enraged multitude shouted, "We have no king but Caesar."

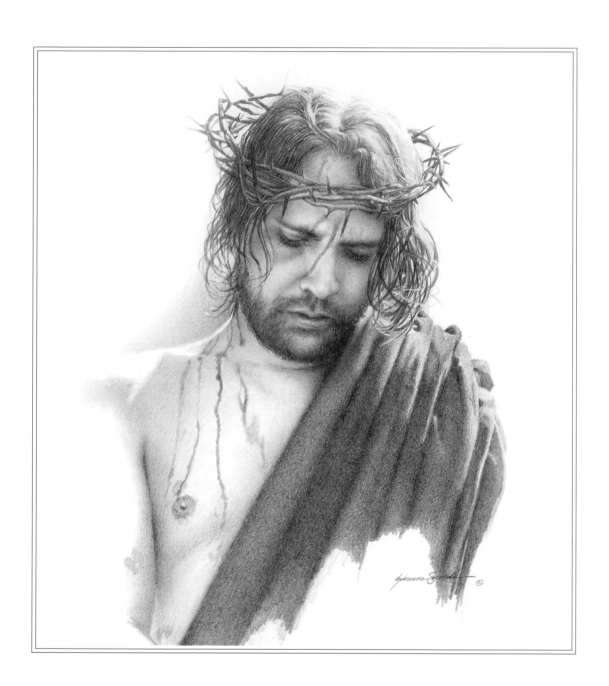

Who committed blasphemy that day in Jerusalem? Was it the condemned Jesus of Nazareth? No. Had those standing near the fortress forgotten the purpose of the Passover festivities? Had they forgotten that God led the children of Israel out of Egyptian bondage? Had they not longed for the King of Kings to rescue them from Roman dictators? Had they not wished for the Son of Man to take his rightful place as ruler over Judaea? That day there were but few disciples who remembered the goodness of God to the children of Israel and who acknowledged Jesus of Nazareth as the King of Kings. Peter, James, and John knew of his status, Lazarus and Martha knew, and so did Mary, the mother of Jesus—yet they all were powerless to stop the tide of evil in Jerusalem. Jesus was condemned to be crucified.

A cruel fate, yet a wondrous plan. A plan that required no less than his mortal life to save a fallen world. Could Jesus, the King of Kings, knowing the cruelties of crucifixion that lay ahead, say, "Thy Will, O Lord be done?" Could he retain his humility and

Did the soldiers not know that the makeshift attire—from the scarlet sagum to the twisted garland—bespoke the true identity of the condemned?

be the lowly Lamb when thoughtless men ridiculed, mocked, and derided his every move? Would he back away from his final journey—a journey to Golgotha, the place of skulls, from which none but a God could return? Would he call upon angels to deliver him from the torturous events of the cross or did he so love the world—a world fraught with error—that he would die to save us all?

The prospect of crucifixion was a defining moment for Jesus and his oppressors. In crucifixion, oppressors saw an end to the miracle worker of Galilee and the growing threat to their dominion. Jesus saw only redemption and a divine appointment—an appointment that would take his very life. No wooden cross or crown of thrones could keep him from being the prophesied Sacrificial Lamb.

For his resolute determination to fulfill the wondrous plan of God, we shout with those in ages past, "Hosanna to God in the Highest!" "Let Heaven and Earth his love proclaim!" "He left his Father's courts on high, with man to live, and for man to die."

*A*nd when they had platted a crown of thorns,
they put it upon his head, and a reed in his right hand:
and they bowed the knee before him, and mocked
him, saying, Hail, King of the Jews! MATTHEW 27:29

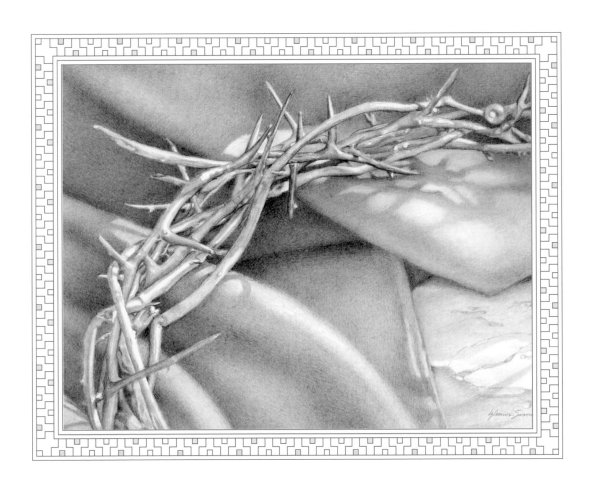

OUR REDEEMER,
OUR SAVIOR

CHAPTER 3

PONTIUS PILATE turned Jesus over to Roman soldiers to execute the mandated crucifixion. They were to take Jesus from the Antonia Fortress to the street below, where a military procession was being assembled. Once on the street, the soldiers were to have Jesus join two thieves who also faced crucifixion that day. Each of the condemned men was to carry a heavy wooden crossbar through Jerusalem, out the city gate, and up the hill to Golgotha, or place of the skull. To prevent the condemned from tarrying or fainting along the way, soldiers escorted them,

and, when necessary, prodded them forward. These military processions were common in Jerusalem, especially during Passover week. They served to remind the Jews of their inability to throw off the rule of the Roman Empire. The military processions always attracted curious spectators who hurried to see the condemned, but quickly turned away from the death march. This procession, however, proved different.

As news of the conviction of Jesus spread to every quarter of the old city, young and old came to see—some for the first and others for the last time—the famed healer of Galilee. Most in the crowd were not prepared to watch Jesus stagger under the weight of the crossbar or witness the physical abuse heaped upon him by Roman soldiers. Women, seeing his weary shuffle and his marred countenance, openly wept in commiseration. "Daughters of Jerusalem, weep not for me," Jesus said. When he stumbled and fell, unfeeling soldiers did not pause to sympathize or even acknowledge the concerns of those in the crowd. Without missing a step, soldiers pulled Simon, a Cyrenian, from the crowd and forced him to carry the crossbar of Jesus, assuring spectators that nothing would slow or halt the procession.

Once on the hill, soldiers, expert in the methods of crucifixion, offered "vinegar to drink mingled with

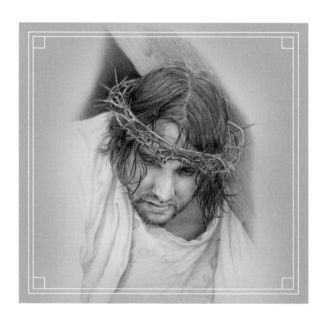

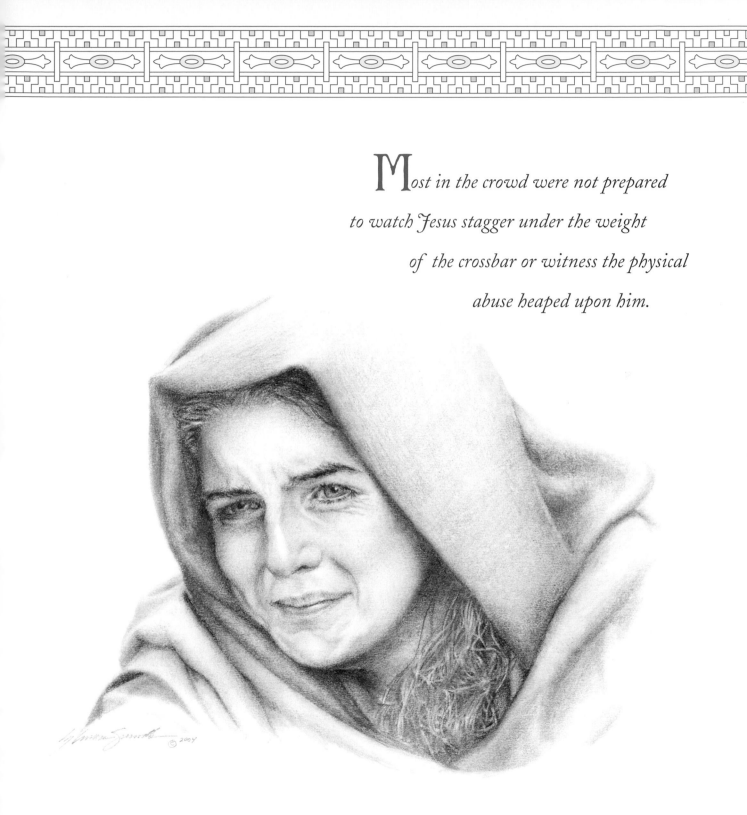

Most in the crowd were not prepared
to watch Jesus stagger under the weight
of the crossbar or witness the physical
abuse heaped upon him.

gall," to the condemned. Although the mixture deadened sensibility and eased the pain of crucifixion, Jesus "received it not." His refusal made no difference to the soldiers; they had a duty to perform, and whether Jesus of Nazareth was unduly pained in the process was of no consequence to them. With hammers in hand, the soldiers pounded iron nails into the palms and wrists of the condemned, careful to secure their hands to the crossbar before lifting the bar to the worn post, already in place. The soldiers then hammered nails into the feet of the condemned to prevent the weight of their bodies from pulling away from the post. To clearly identify the crime of each condemned man, the soldiers nailed a separate title atop the three posts. The title nailed to the post on which Jesus now hung read: "Jesus of Nazareth, the King of the Jews."

As Jesus hung helpless from the bar and post that formed a makeshift cross, Jewish leaders—the same ones who had orchestrated the urgent call for crucifixion at the Antonia Fortress—approached him. They had not come to ask for forgiveness of their sins. They

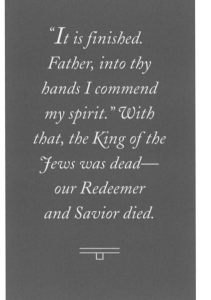

"It is finished. Father, into thy hands I commend my spirit." With that, the King of the Jews was dead— our Redeemer and Savior died.

had climbed Golgotha to harass Jesus. "If thou be the Son of God, come down from the cross. He saved others; himself he cannot save. If he be the King of Israel, let him now come down from the cross, and we will believe him. He trusted in God; let him deliver him now, if he will have him: for he said, I am the Son of God." One of the condemned thieves, hanging on a cross next to Jesus, thoughtlessly joined in the ridicule. The other thief asked him, "Dost not thou fear God, seeing thou art in the same condemnation? We receive the due reward of our deeds: but this man hath done nothing amiss." Turning to Jesus, the penitent thief pled, "Lord, remember me when thou comest into thy kingdom." Jesus answered him, "Verily I say unto thee, Today shalt thou be with me in paradise."

Such kind words continued to flow from Jesus even though the derision went unchecked. As Jesus looked down from the cross, he saw soldiers parting his clothing, their gratuity for standing guard until the crucifixion process brought death to the condemned. Jesus said, "Father, forgive them; for they know not

what they do." To his mother, Mary, who stood near the cross, Jesus said, "Woman, behold thy son!" To his disciple John the Beloved who also stood near, he said, "Behold thy mother!" But to the leaders of Judaism, those who failed to acknowledge him as the Redeemer, the Savior, the King of Kings, Jesus expressed no words of comfort. He gave them no assurance of an eternal place in paradise or hope of forgiveness for their duplicity or iniquity.

His silence toward the antagonists did not stop their abuse of him. They continued their hostile refrains, even when Jesus, in anguish, cried aloud, "Eli, Eli, lama sabachthani"(My God, my God, why hast thou forsaken me)? Instead of sympathizing with the condemned, a Jewish leader said, "This man calleth for Elias, let us see whether Elias will come to save him." As the irreverent looked upward, Jesus lowered his head and said, "I thirst." In compassion, one man "ran, and took a spunge, and filled it with vinegar, and put it on a reed," and attempted to give him drink but was prevented by a Jewish leader who said, "Let alone; let us see whether Elias will come to take him down." As the ungodly watched for a miracle, the coming of Elias, Jesus said, "It is finished. Father, into thy hands I commend my spirit." With that, the King of the Jews was dead—our Redeemer and Savior died on a cross.

The sun hid her face in shame, darkness shrouded the skies over Jerusalem, and the earth groaned in tumultuous convulsions for Jesus, the King of Kings, was no more. The dead arose from their graves and walked the streets of Jerusalem. The veil of the temple was rent in twain from top to bottom. Fear filled the land. Women, standing near the cross, "smote their breasts" and a centurion cried aloud, "Truly this was the Son of God." Never had there been such a day in Jerusalem. The Holy City, without the Son of Man to rule and reign, reeled in fearful darkness and tumult.

Yet the Roman-appointed leader of Judaea, Pontius Pilate, was nowhere to be seen. He was not at his post calming fears or attending to the myriad emergencies the great earthquake had wrought. He was not bowing before one of his pagan gods pleading for the return of sunlight. Instead he was behind closed doors, talking with the Jewish leaders who had stood near the cross speaking evil against Jesus. Were they so powerful that they could command the attention of Pilate at this time of chaos? It appears so. These men had not come to speak with Pilate about darkness, a torn temple veil, or tumult in the land. They spoke only of safeguarding the sanctity of the approaching Sabbath—the Day of the Lord. To them, leaving condemned men on crosses at Golgotha awaiting

IT IS FINISHED (Overleaf)

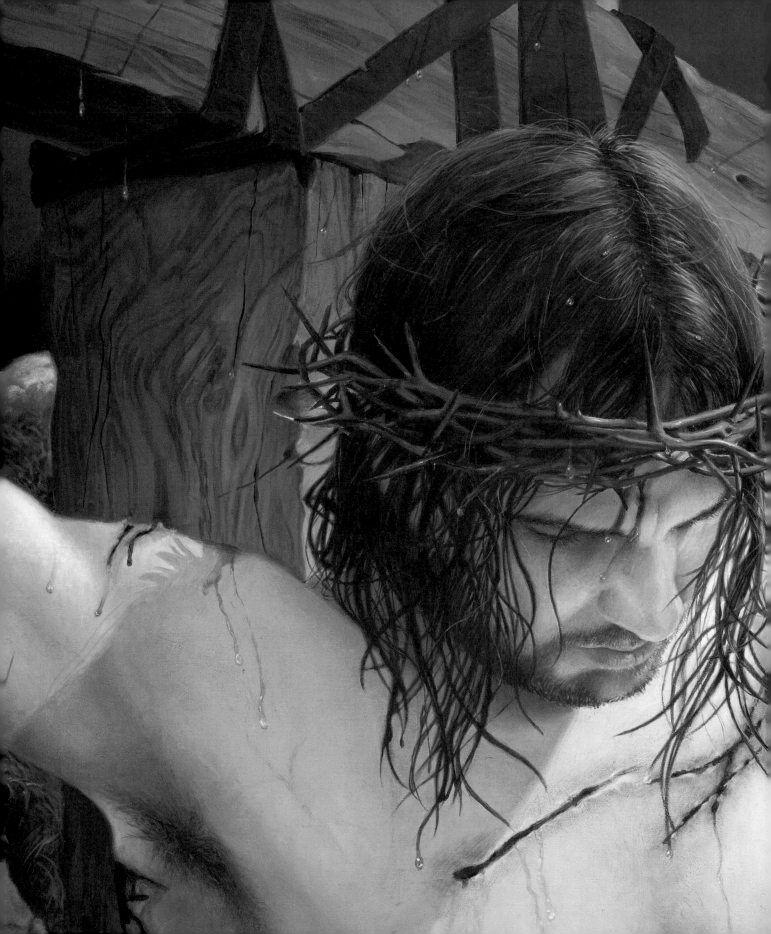

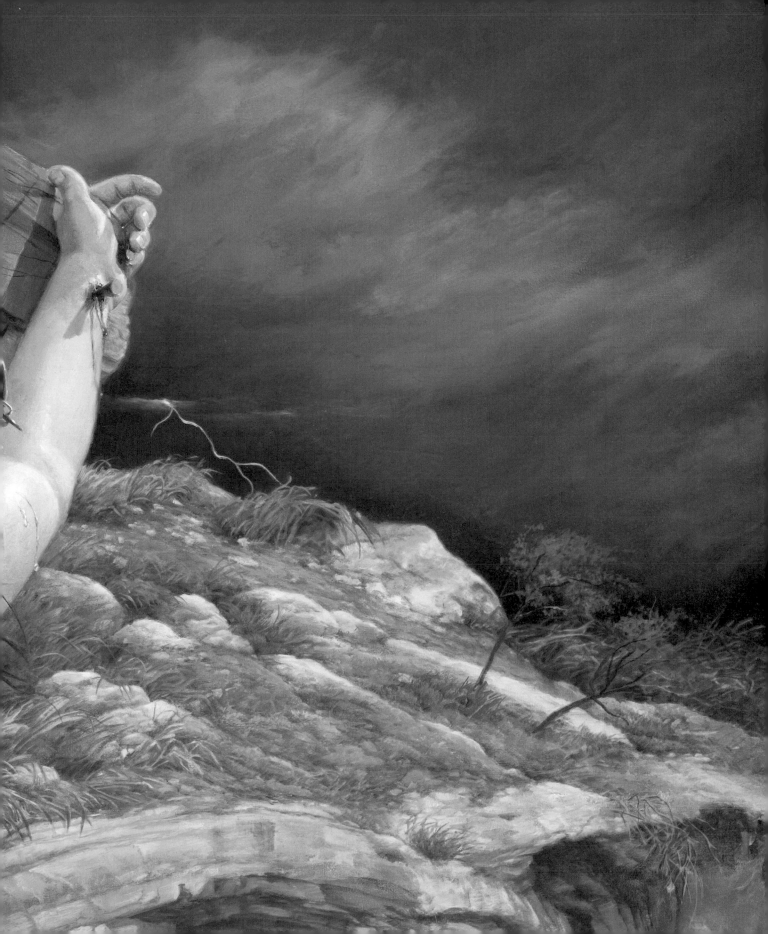

crucifixion would be a violation of the Sabbath. The leaders demanded that Pilate command his soldiers to break the legs of the condemned to expedite the crucifixion process so their dead bodies could be removed from the crosses before Sabbath.

Were the Jewish leaders so far removed from reality that they were unaware that Jerusalem reeled with convulsions and darkness hung over the land? Did they not know that fear permeated every heart—even the hearts of the soldiers? Certainly they knew of these problems, but to them the sanctity of the Sabbath was much more pressing. With more frustration than formality, Pilate agreed to their demands, much like a puppet on a string. And like their controlled leader, the soldiers hurried to fulfill his directive. They broke the legs of the thieves to hasten their deaths. Breaking of the legs of Jesus was not necessary—they found him dead. Yet "one of the soldiers with a spear pieced his side, and forthwith came there out blood and water."

Upon hearing of the death of Jesus, Joseph of Arimathea—a disciple of Jesus, an honorable counsellor, and a rich man—sought a meeting with Pilate. Pilate agreed to see Joseph and learned from him that Jesus was dead. Pilate marveled that he had died so soon, never equating his death with the darkness that engulfed the

DISCIPLESHIP

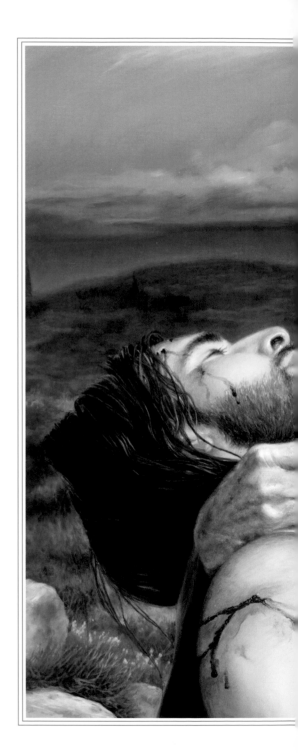

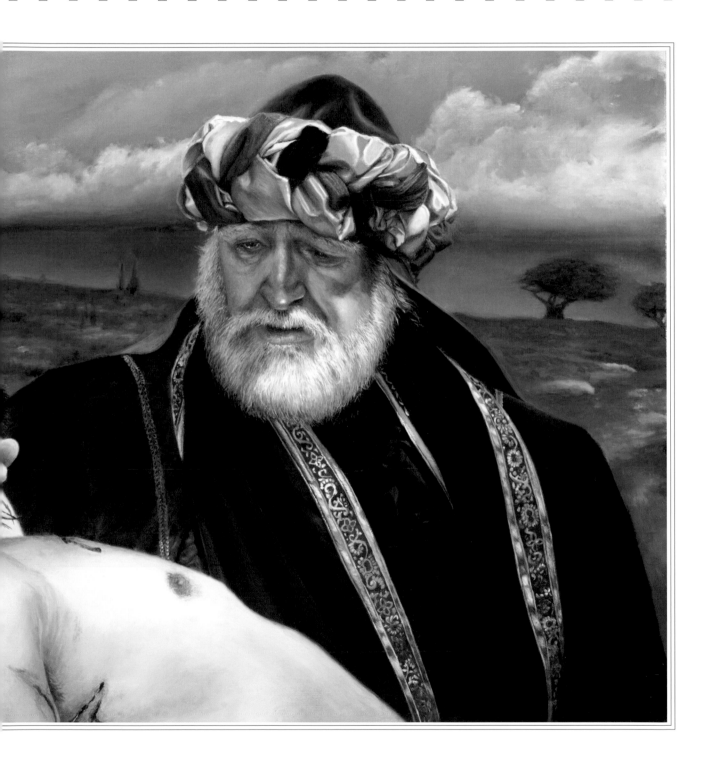

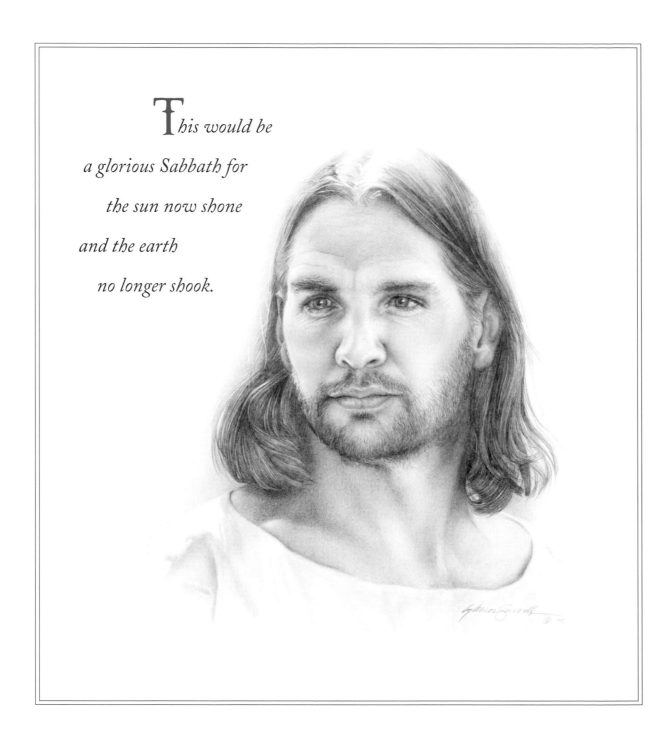

*T*his would be

a glorious Sabbath for

the sun now shone

and the earth

no longer shook.

land or the great earthquake that rocked the holy city. Pilate further marveled that Joseph would stoop so low as to beg for the right to bury the body of Jesus. This was an unusual request that was difficult to deny; according to Roman law, an insurrectionist had the right to an honorable burial, Jesus not excepted. Thus, Pilate granted Joseph's petition.

Joseph, with other disciples of Jesus, hurried to Golgotha to retrieve the body of Jesus of Nazareth. They took his body from the cross, wrapped it in a linen cloth, and carried it to the nearby garden tomb that Joseph had "hewn out of a rock." The Herodian style tomb had two chambers—an outer one for wrapping the deceased and an inner one, with niches carved in the stone, for burial purposes. It was in the outer chamber that Joseph and fellow disciple Nicodemus prepared the body of Jesus for its journey into the eternities, a Jewish custom. Accordingly, they washed the body before rubbing oil and sprinkling perfume upon it. They then wrapped the body in grave clothes made of long strips of linen, forming a "tachrichin" or traveling-dress. Myrrh and aloe "about an hundred pound weight," which Nicodemus had brought with him to anoint the body, were packed between the cloth strips to lessen the stench of death. The wrappings and the powdered paste produced by the myrrh and aloe

formed a type of cocoon that covered the deceased, except for his head, which was bound with a linen napkin, much like a twisted turban. When the dressing of the deceased was finished, the body of Jesus was placed in a niche in the inner chamber "wherein was never man yet laid." A disk-shaped stone was rolled edgeways in front of the entrance to the chamber to shield the remains from intruders and wild animals.

Confident that their actions had been appropriate, Joseph and Nicodemus left the garden sepulchre and hurried to their homes to prepare for yet another Sabbath. This would be a glorious Sabbath for the sun now shone and the earth no longer shook. It was almost as if the sky had not grown dark, the earth had not groaned, and Jesus had not died on a cross at Golgotha.

The next day Jewish leaders, once again, made their demands to Pilate: "Sir, we remember that deceiver [meaning Jesus] said, while he was yet alive, 'After three days I will rise again.' Command therefore that the sepulchre be made sure until the third day, lest his disciples come by night, and steal him away, and say unto the people, He is risen from the dead: so the last error shall be worse than the first." As if wearied by their demands, Pilate said, "Ye have a watch: go your way, make it as sure as ye can." The leaders left Pilate and hurried to the sepulchre where Jesus lay. They did

HOPE (Overleaf)

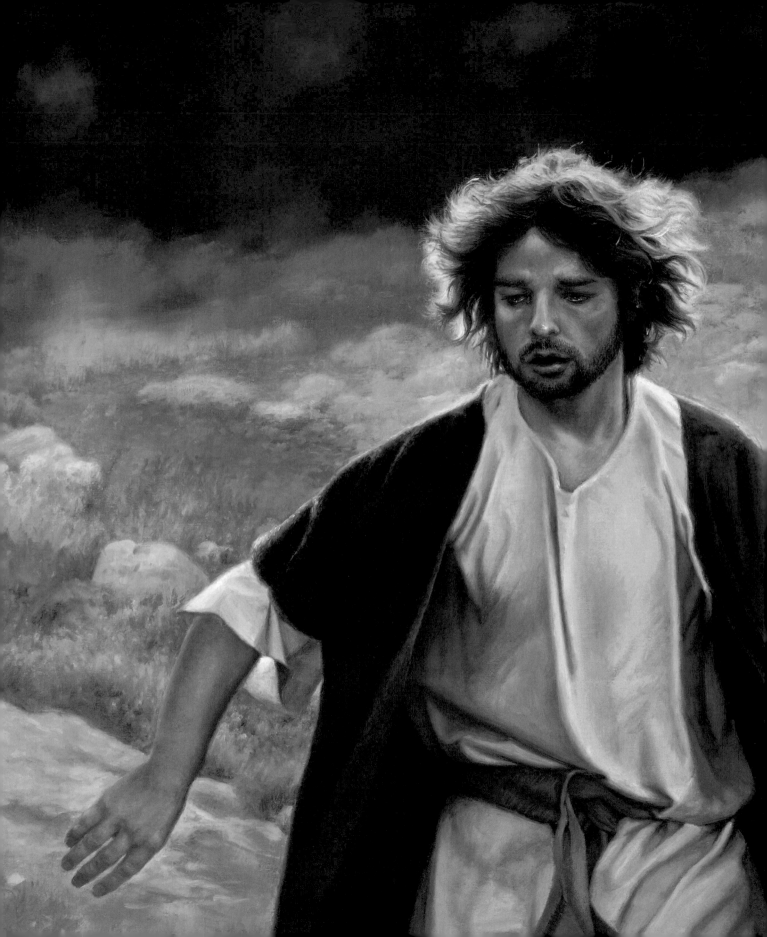

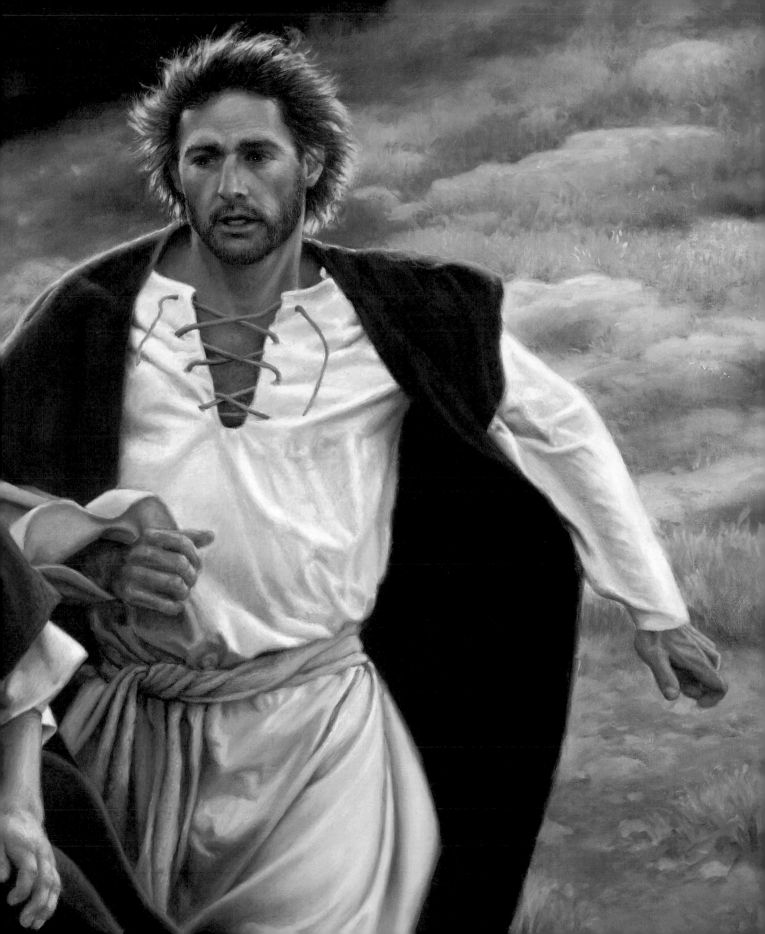

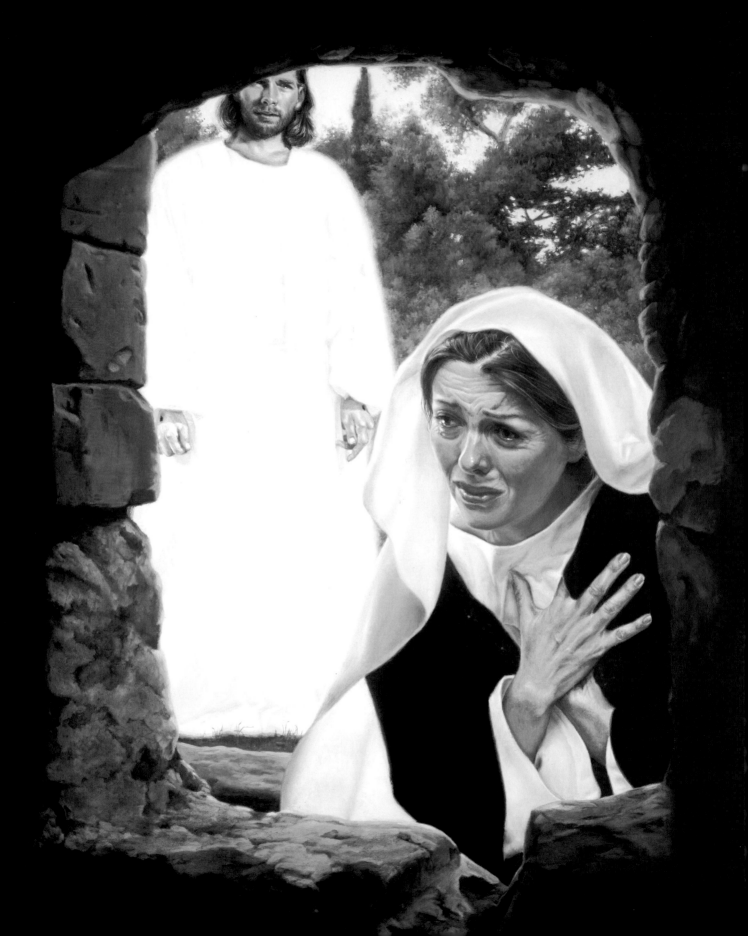

not go inside the inner chamber to check his wrappings or see his remains. Instead, they busily worked to seal the stone in front of the burial chamber to assure that the deceased could not rise the third day. They even stationed soldiers to guard the tomb. Confident that they had secured the sepulchre, the Jewish leaders left.

What seal could prevent Jesus from rising on the third day? What soldier could keep the crucified Jesus from becoming the Resurrected Lord? It is foolish to conceive of a seal or a soldier that could thwart the great plan of Jehovah, the resurrection of Jesus Christ. Jesus did arise on the third day, and a privileged few were able to see him. Among them were Mary Magdalene and another Mary who came "unto the sepulchre at the rising of the sun." They, and the other women who followed them, had plans to examine the wrappings of the deceased and add sweet spices. Instead of finding the body as they had supposed, they saw an "angel of the Lord descended from heaven, and came and rolled back the stone from the door, and sat upon it. His countenance was like lightning, and his raiment white as snow." The angel said, "Why seek ye the living among the dead? Fear not ye: for I know that ye seek Jesus, which was crucified. He is not here: for he is risen, as he said. Come, see the place where the Lord lay." The women saw only an empty tomb.

The angel directed the women to "Go quickly, and tell [Jesus'] disciples that he is risen from the dead." In obedience and possibly out of a sense of fear, the women ran "to bring his disciples word." They found his disciples in a solemn mood, still mourning the loss of Jesus. The women interrupted and told the disciples of the empty tomb and a Resurrected Lord. To the disciples, these "words seemed to them as idle tales, and [the disciples] believed them not." That is, all but the apostles Peter and John, who immediately left the gathering and ran to the tomb to see whether Jesus lay among the dead. John outran Peter and reached the sepulchre first. He stooped down and "looking in, saw the linen clothes lying; yet went he not in." When Peter reached the tomb, he went into the sepulchre and found it empty, just as the women had said.

News of the empty tomb spread quickly throughout the old city. The news was glorious to the disciples of Jesus, but it disturbed the Jewish leaders. How could they prevent the people from following Jesus with such news going unchecked? They concluded the best way to stop the rumors was to give a large sum of money to the soldiers who guarded the tomb, upon condition that the soldiers explain the empty tomb in this way: "His disciples came by night, and stole him away while we slept." The fearful soldiers agreed to the lie when

the Jewish leaders promised "if this come to the governor's [Pilate's] ears, we will persuade him, and secure you." With soldiers countering the words of Peter, John, Mary Magdalene, and the other women, rumors of a Resurrected Lord held little credence to most in Jerusalem.

But among the disciples of Jesus, there were those who knew with certainty that their Master had risen from the dead. One such disciple was Mary. While "Mary stood without at the sepulchre weeping: and as she wept, she stooped down, and looked into the sepulchre," she saw two angels sitting where the body of Jesus had lain. The angels asked, "Woman, why weepest thou?" She answered, "Because they have taken away my Lord, and I know not where they have laid him." And after she had "thus said, she turned herself back, and saw Jesus standing, and knew not that it was Jesus." Jesus asked Mary, "Woman, why weepest thou? whom seekest thou?" Thinking him a gardener, she replied, "Sir, if thou have borne him hence, tell me where thou hast laid him, and I will take him away." Jesus said, "Mary." It was his familiar voice. She then knew with certainty of his resurrection.

Likewise, Cleopas and Luke on the road to Emmaus knew that Jesus lived again. Jesus communed, reasoned, and even chided these men for being "slow of heart to believe all that the prophets have spoken." Similarly, disciples fishing at the Sea of Galilee knew Jesus had been resurrected. They, like Mary and the two men on the road to Emmaus, did not recognize him at first. "Children, have ye any meat?" Jesus asked of them. "They answered him, No. And he said unto them, Cast the net on the right side of the ship, and ye shall find." The net was cast on the right side and immediately filled to overflowing with more than a day's catch of fish. In recognition, one disciple shouted, "It is the Lord." They then hurried to greet him. From that day forth, his disciples were "continually in the temple, praising and blessing God" for the miracle of the Resurrected Lord. They could not be restrained from sharing the glorious news of his resurrection, even if it meant imprisonment or worse. Their testimony was sure for they had seen the resurrected King of Kings, the Son of Man.

From city courts to rural byways, the apostles spoke of Jesus Christ. The honest in heart listened and rejoiced in the knowledge that death was conquered, men set free, and Jesus had won the crowning victory. Although Pilate and his soldiers were an ever present force, foreign oppression could not destroy the newfound hope and faith that Jesus, the miracle worker of Galilee, was the King of Kings.

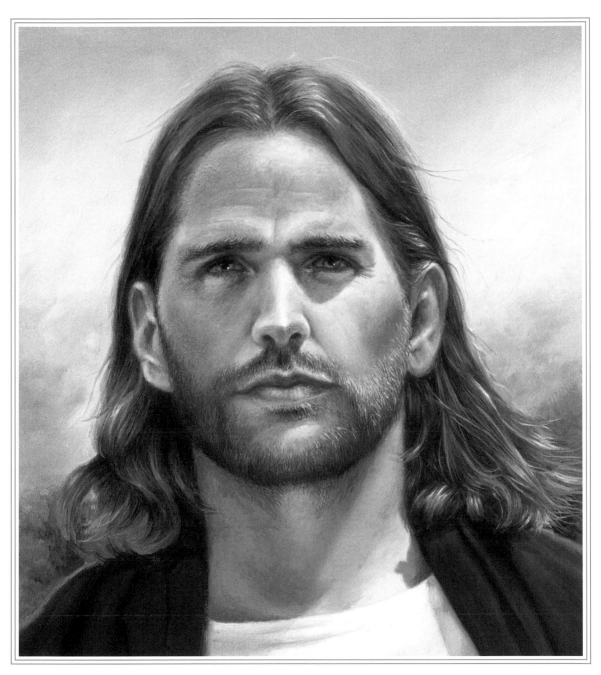

SEEKING THE ONE

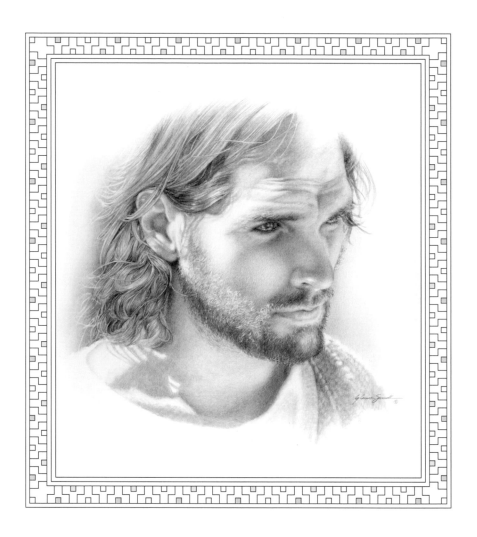